roberto cavalli

© 2001 Assouline Publishing for the present edition
601 West 26th Street, 18th floor
New York, NY 10001
USA
Tel.: 212 989-6810 Fax: 212 647-0005
www.assouline.com

First published by Editions Assouline, Paris, France

Color separation: GEGM (France)
Printed by Grafiche Milani (Italy)

ISBN: 2 84323 392 5

roberto cavalli

JAVIER ARROYUELO

ASSOULINE

Siamo belli quando siamo amati is the axiom, the thought for life, that Roberto Cavalli claims to have passed on to each of his five children: "We are beautiful when we are loved". He could as well have had it engraved on the front of his stores and made it a recurrent slogan in his ads, for it fits perfectly his aesthetic world, ruled by amorous desire. And were he to print it over the clothes he signs, we would witness a widespread surge of torrid romanticism, for if there is right at this moment a fashion assuredly in fashion – as it were, indispensable for the press, loved and enjoyed by trendsetters and their epigones and faithfully duplicated in the streets as well – that is, indeed, Roberto Cavalli's fashion.

After the strictness and earnestness and the sometimes laborious experiments of post-modernism, Cavalli jumped out of his box – or rather his juke-box – with his comic-strip baroque inventory,

which by way of its deliberate profusion and its striking visual power is ideally suited to the fantasies of the times. Huge vibrant and contrasting prints – zebra stripes and tiger patterns, leopard spots, romantic blossoms, optical and photographic effects after the manner of contemporary artists – are Cavalli's trademark, along with colors that are anything but timid and lavish ornamentation, all used without restraint and combined into cheerful jigsaws, bold collages and uncommon juxtapositions of fabrics, textures and themes. Crisp cutting defines a graphically sensual silhouette: the body is taken care of, flattered or even corrected, if necessary. Cavalli's archetypical style: the stretch jeans, a true hit, that fittingly slim down the hips while perking up the behind.

a dedicated researcher, captivated by textiles and materials like a painter by canvas, Cavalli ceaselessly discovers new ways to use them. At his beginnings, he experimented on leather, which he rendered as supple as a fabric and then printed, and on denim, both used in patchwork patterns and metallized. Then came muslin and lamé, silk, velvet and jersey, fur and leather – that he garnishes, embroiders and re-embroiders, embosses, weathers, dyes, crushes and crumples, encrusts, inlays, pierces, lightens or darkens – materials that he celebrates in short, with the skill of an expert craftsman and the uninhibited imagination of an artist.

A style as resolvedly flamboyant as Cavalli's, at odds with any kind of modesty, sparkling and lavish, sharp and rakish, couldn't possibly be ignored by the kings and queens of pop. In significant unison, a whole assembly of video stars and other defenders of

the doctrine of glamour – like Jennifer Lopez, Lenny Kravitz, Britney Spears, Mary J. Blige, Cindy Crawford, Elton John or Madonna – have adopted it and flaunt it before the cameras of the world. In everyday life – if we may say so, for these are in fact rather a quite exclusive everyday and a truly lush life-Roberto Cavalli embodies for his legions of fans a new, vivacious – and therefore fully dependable – approach to luxury. For them he updates the enduring concept of gilded youth.

f ull of vim and vigor, as one might deduce from his creations, Roberto Cavalli, who was born in 1940, has in fact reached the age category at which most fashion designers consider retirement, or are kindly requested to do so. The matter is totally out of the question for a man who has just find again – largely amplified – the kind of success he knew much earlier in his career. Back in the early 1970s, Cavalli was one of those who brought Italian fashion onto the international scene. From Saint Tropez to Beverly Hills, his miniskirts and maxi coats were all the rage, Brigitte Bardot and Sofia Loren were the first names on the list, unfolding as of this day, of his rich and famous fans, socialites and stars, and each and every element of the Cavalli look as we know it was already in place. Over the past three decades Roberto Cavalli has remained true to his themes, his ideas and his research. He's a genuine creator, who ignores the sacrosanct laws of the In and the Out and invents his own seasonal variations – all of which explains the somewhat notorious wilderness years between his early success and his present preeminence.

Cavalli is a passionate man and the path of his life, mainly made of dramatic twists and turns, could very well serve as the story-line for a soap opera – digitized, in a 16/9 format, and, of course, in the persistent colors of his high-tech rainbow.

i n 1957, Italy enters a period of economic growth and full employment. The ensuing years of prosperity are known as those of the Italian miracle – a time when the country opts for modernity. A whole generation of artists, writers, film-makers and designers emerges, all equally committed in a quest for new forms, all equally eager for change. That same year Roberto Cavalli, still an adolescent, enrolls at the Institute of Art in Florence, his native city *"after I'd tried quite a few other directions"*. Yet, art is in his blood – after all, his maternal grandfather, Giuseppe Rossi, with whom he had spent his child-hood, was a well-known painter and portraitist of the Machiaioli school – the Florentine impressionists. Roberto studies painting, and chooses a good direction by specializing in textile applica-tions. He intends to become a *stampatore,* or textile printer. He starts working with a classmate, Elena Mannini, now a highly reputed theatrical costume designer in Italy, then a designer for a knitwear factory in Florence. They install themselves in an attic studio, painting by hand and using a tiny printing table. They apply floral motifs onto finished pullovers, following the "fully fashioned" method in which the design covers the article of clothing in its entirety.

It's an appealing novelty and soon, thanks mainly to word of mouth, Cavalli supplies the most important Italian knitwear

houses. While the economy of Italy keeps booming, Cavalli's workshop grows into a factory. In 1966, he moves it out of town to Osmannoro, a marshland area near Sesto Fiorentino. Sixteen people work there, solely on knitwear. On November 4th 1966 a mudslide hits the region and the factory is totally destroyed. Cavalli starts from scratch again, striving harder yet.

rather than the year of the red revolt, 1968 is for Roberto Cavalli that of his first white Maserati. Yet, although he's certainly not longer a bohemian student, he has not at all turned into a boring big boss. Indeed, because his company thrives, he can afford to remain a whimsical bon vivant or – as he says himself with a good deal of self-irony – carry on acting as a 'little playboy'.

Sometimes, listening to Cavalli tell his own story, you feel you've been transported into an Italian comedy movie, with Cavalli himself, of course, in the ineffable leading role.

Exterior. Dusk. The camera pans over the hills of Fiesole, Sumptuous September light. A very chic party goes on at a beautiful villa. Two gatecrashers quite relaxed in a deluxe convertible, creep into view: they are Roberto Cavalli and his best buddy, both as gorgeous as the sun, according to the main protagonist. Their eyes – and the camera as well – glide over a living frieze of ravishing young women, the one and only reason for their presence at the party. Out to impress the prettiest of them all, our hero, asked what trade is he in, answers that he specializes in printed leather – a highly original claim since the trade at that point doesn't actually exist. Cut to new scene. Day. Interior. Studio. A beaming Roberto Cavalli holds out a piece of engraved

leather. He has just created an entirely new method, between art and industry, which will make his fortune.

He decides to test it out in the headquarters of fashion, Paris. Prestigious *maisons* like Hermès or Pierre Cardin are among his very first clients. Seizing the opportunity, Cavalli quickly sets up his very first show, in 1970, at the Salon du Prêt-à-Porter. His mini and maxi skirts, jackets and minidresses with a modern art touch are a hit with the press, but buyers are rather disconcerted. After two more Paris seasons, he sets off for Munich in 1971 to show a collection of basics – jackets, shorts and little coats in patchworked leather – co-created with the designer Henry Lehr. To his delight, he's then invited to present his next collection along the most famous names in Italian fashion, as part of the official showings at the Pitti Palace in Florence – his native town.

C avalli is a guest perfectly at ease at the party that was the 1970's. He grasps, and goes along with, the Zeitgeist, yet at his own pace, as he would always do. He captures the attitudes of the young people of the day, the looks that define the moment, and gives a version of it all in which his fondness for éclat bursts forth: he's into rock'n'Rolls Royce, he's into flower *super*power. He recycles a heap of blue jeans found in a container coming from the USA, where they return as highly wearable patchwork ensembles and are a sell-out. 1971 is the year of his first smash hit, his first million dollars and his first real encounter with the United States, then beginning to count in fashion, thanks not only to their commercial weight but also to the creative stir manifest on many fields and the vitality of its popular culture. At decisive moments in his

career Cavalli always drew an important part of his success from the esthetic links he was able to make with different sections of the American public. Another recycling, another masterstroke: he treats a surplus stock of accidentally blue-dyed leather with a metallizing finish. He obtains a beautiful gold lamé, which he then adorns with floral motifs. The Midas touch works: "That was my historic breakthrough", he says. In 1972, he opens a boutique. Where else than Saint Tropez? It's called Limbo, like the limbo of psychedelia – or better yet of success: "I was the star of the Sala Bianca at the Pitti Palace". He introduces himself to his American fans as a Florentine artist of fashion. Suede, denim and soft, ductile leather are his favorite materials. He cuts them apart and sews them back together into geometrical patterns, covers them with Renaissance flowers, paisley patterns, butterfly wings or cabbage roses, makes them look like precious metals, python skin or brocade and fashions them into shorts, tunics, waistcoats, full skirts, trousers, masculine blazers and swinging coats and capes, all essential equipment for fancy jet-setters.

but this brilliant cycle is to end with the decade. In 1978, "Made in Italy" fashion is at its height. Most of the Italian *prêt-à-porter* brigade chooses then to leave Florence, considered too unpractical for international travel liasons, and head for Milan, Italy's virtual capital and economic powerhouse. Roberto Cavalli admits " it wasn't a happy time. A way of life that, in my view, remained convivial and allowed an artistic bias was coming to an end. We were moving into the world of mass production and out and out mass marketing". Armani,

Basile, Genny, Missoni, all bid farewell to the Pitti Palace, taking along the buyers and the journalists and *"all that folklore"*. Out of attachment, and probably stubbornness as well, Cavalli stays in Florence: "I boarded the wrong train". He'll look on as the caravan of fashion gradually disappears over the horizon.

g rand hotels, long journeys, big cars, intense love affairs: in 1978 the life of Roberto Cavalli, long since divorced from his first wife, has all the glossy trappings of a Playboy reader's dream. As if to prove it, he is invited as a member of the jury to the Miss Universe contest, held that year in Santo Domingo. He can't take his eyes off Eva Duringer, the Austrian contestant, a suave blonde with classical features, who wins the title and with it a boyfriend twenty years her senior. The law by which, supossedly, opposites are mutually attracted is once again corroborated: the Latin male, impulsive and passionate, and the Northern girl, placid and stable, are soon married.

At a professional level, Cavalli continues his research, now as a quite exclusive designer. For his fans in Italy and Germany and in the United States, most of whom zealously collect his clothes, he remains the embodiment of a lifestyle. But to Cavalli, the 1980s bring fulfillment on a much more personal level. Two children are born to the couple. He rediscovers family life and realizes that *"there's nothing in this life more gratifying than being a father"*.

Eva joins the Cavalli firm to look after sales in Germany, its most important market. But Roberto is simply not in the mood for business. He goes through a melancholy phase and feels he has no other option than discontinue his own brand: *"it was no*

*longer the adventure I had known and it no longer gave me plea-
sure"*. He conscientiously begins union negotiations with his
employees. At the same time, still creative and curious in spite
of everything, he tries yet a new technique on yet another new
fabric. This time, he attempts to "age" stretch denim through a
sand-blast process. He shows the jeans so treated in Milan, at
the Modit trade fair, where *"I saw clients coming back who had
been gone for fifteen years. It brought tears to my eyes. In a mat-
ter of months, my name was going round again. Some people
probably thought I was a new designer"*.
Cavalli's comeback is sanctioned with a show in Milan in
September 1994 and by December that year a boutique opens in
Saint Barth, followed – true to the logic of the geography of lux-
ury – by others in Saint Tropez (1995) and Venice (1997).
Definitely to the taste of our master of bold glamour, his return
makes quite a splash.

●

I n the Nineties, his success reaches the speed of Concorde
and then some : in the matter of a few seasons, Roberto
Cavalli is rediscovered, reassessed and then acclaimed,
the trend turns into a craze and the craze into a triumph. Some
say that it has now reached the cult stage. It seems that beyond
his great impact on fashion or the ultimate uniqueness of his
style, what really does count for the followers of Cavalli is the
fantasy lifestyle that he embodies. In Italy, someone dubbed this
phenomenon 'Cavallinitis'. Funny, but inaccurate, since the *-itis*
suffixe denotes only an inflammatory or manic condition. Now,
Cavallism would certainly be a more fitting word, for the truth is

that beyond the boundaries of a seasonal craze Cavalli has in fact set a new school of fashion. It isn't certainly the Hollywood stars alone who make the company's yearly turnover jump to around two hundred million euros. Lucid, though perhaps a bit too modest, Cavalli explains his huge success first and foremost as a backlash against the boredom of the fashion-conscious after more than one decade of total immersion in minimalism. Yet, it has to be recalled that throughout the 1980s, while Cavalli himself was rather out of the spotlight, other designers had adopted his style. Their imitations helped to assure its continuity. But tastemakers, an informed and affluent group, for whom fashion is an important social link, adopted minimalism as the one and only poltically correct fashion option. In minimalism, luxury is constrained to never reveal itself as such. Ostentation is banished. Though costly, the clothes must never, at any price, appear rich. This voluntary impoverishment is supposed to imply some kind of transcendency. Discretion, subtlety and a long list of of sartorial and decorative interdictions and abstentions set the rules by which minimalism goes by. All of Roberto Cavalli's beliefs and usages are the exact opposite of such restrictions. Rather than domesticate taste, he prefers to set it free. He favors unexpected choices and spontaneous moves.

Whenever Roberto Cavalli's clothes are involved, the very act of dressing becomes an event. Intrepid, intense and Italian, Cavalli is able to give a theatrical twist even to a banal pair of jeans. Many of his clothes are somehow related to the bullfighter's costume, the *traje de luces*, literally the 'habit of lights'. Spectacular as they are,

Cavalli garments give their very best in the indiscreet glare of the summer sun, outlined against the neon lights of some downtown area, caught in the intersecting beams of the searchlights, slashed by camera flashes, and in dance-clubs glittering under the silver drops of revolving mirror balls. To wear these clothes is a sure way to find out what good old fashion drama is all about. In a Cavalli, even stars think they're stars.

In order to make such fantasy work — or make believe it'll work — Cavalli takes spectacular measures.

a s a wizard of prints, he uses the very latest technology to produce his knock-out graphics. He likes to walk about outdoors with a digital camera in hand, capturing whatever catches his eye. Furs and feathers, scales and shells, the bark of a tree, the ripples on a pond, crystals and chrysalids, cacti and red poppies, the spots of a giraffe or the transparence of an eye's iris: he has zoomed in on all that, he has blown all that up on his screen. By watching at Nature at such close range, he has discovered that it reiterates some of its patterns from one species, or even a kingdom, to another. He recognizes in a beetle's wing sheath a mineral motif, in a fish the stripes of a zebra. *"I'm amused by the idea that God repeats himself"*.

His waves of colors have certainly a source in the audacities of that other Florentine designer, Emilio Pucci, who fifty years ago found inspiration for his celebrated prints in the jackets and banners of the Palio of Sienna. Yet the exuberance of Cavalli's palette is perfectly contemporary: it derives its infinite nuances from digital photography.

Excess is yet another material in Cavalli's hands. He juggles with it. By playing off one extreme idea against another, he manages to achieve a balance. The harmony in his outfits is often based on very strong oppositions. The flamboyance of the total image tends to prevail over the delicacy of each detail. Throughout all this profusion, there is one clear link: Roberto Cavalli's wish to emphasize sensuality by all means. It's a risky performance, which he conducts inventively and with panache, making sexiness chic and vice versa. The sex factor is indeed the key to his startling comeback. In its perpetual quest for newness, Fashion sometimes remembers that it does have a memory. It brings back and recuperates from its own past those elements that might seemingly match the mood of the present. Revivals are rarely carried out by the original creator. By some kind of poetic justice, Roberto Cavalli has had the good fortune to orchestrate his own. He seems to have seized on the occasion to build a small empire. Besides his main collection, sold in over thirty countries, he signe a blue-jeans line, Just Cavalli, and assorted lines of children's clothes, ties and scarves, underwear and beachwear, sunglasses, footwear, watches plus a range of home decoration.

" ●

I *couldn't have been anything but a Dragon"*, says Roberto Cavalli, born under the sign credited by the Chinese with supreme qualities, *"and a Scorpion as well"*. He is also *"a war child"*: on the 4th of July 1944, his father, Giorgio Cavalli, was one of ninety-two Italian citizens shot by Hitler's army in reprisal for an attack by the Resistance, in which a few German soldiers were wounded. Giorgio Cavalli had just majored

in economics, and was working as a land-surveyor for a mining company in the Val d'Arno. Roberto grows up in Florence, where he, his mother Marcella and his elder sister Lietta were taken in by his maternal grandfather. They lived modestly. Even though the family ties are strong, that early tragedy certainly casts a shadow over the child. Today, though, Roberto is convinced that his strength of character, his ambition and his patience were all forged by the grief he then felt. He was a shy child, who stammered. It's easy to imagine him, his mother's favorite darling reigning over the household. We may also assume that women have always gravitated towards him. Roberto, in any case, adores them and says he has had only great loves. His first one, when he was eighteen, was a girl whose well-offparents disapproved of him. They married as soon as he reached his majority, had two children and divorced before Roberto had even embarked on his bumpy career in fashion.

these private circumstances give an essential clue into his character: Roberto Cavalli can talk endlessly about life, affections and emotions. Unlike many of his colleagues, he rarely discusses business in private and even less matters of fashion. Contradictorily, he is miles away from the image his designs project and from the role he plays for the benefit of the press. As famous in Italy as his most famous clients, who are also, as he makes always clear, his friends, Roberto Cavalli has adopted the look of the part, perfect for those evenings of paparazzi and sequins when he nonchalantly displays his public persona. His usual attire consists of a black

leather jacket, a T-shirt, immaculate jeans, Lucchese boots and tinted glasses. His white hair is quite photogenic. He's under the influence of UV rays. He lives with Eva and their three children in a superb hilltop villa, south of Florence. Their home is a converted farmhouse built around a medieval tower. Rooms kept being added along the years, and the centuries, not in a conventional order at all. And that's just as R.C. likes it. In the vast garden, overlooking on one side a travertine swimming pool out of La Dolce Vita, two Persian cats pretend to be wild. Two strident parrots give a final touch of exoticism to the porches transformed in greenhouses. Going from one big room to the next, the décor is hardly the extravaganza described in most magazines.

t he Cavallis collect all kinds of objects, with a weakness for vividness and rarity. Big sofas in the colors of all the families of berries sit next to Madonnas in polychrome wood. In the garage are parked a couple of Ferraris, and Roberto's Ecureuil helicopter, which he used at a time to fly to Paris and back. But this is only one half – one of the many halves, we may say – of Roberto Cavalli. To find the other, we have to follow him all the way up north of Florence to his domain at Osmannoro. There, reunited in a single site constantly expanding around the original factory building, just like the wealthy farmer's house where the Cavallis live, are all the different departments of their company: design studios, archives, ateliers, printing workshops, sales offices and warehousing and distribution areas. In all work in the premises, three hundred people. Eva, his right hand, is never far away. She sorts out and

adapts to the real world the ideas that Roberto keeps launching in every direction. The entire manufacturing process of a Cavalli piece takes place here, from the initial design to the packaging and shipping. Moreover, in a separate room, a wall of video screens is permanently linked to some of the main boutiques - so that every item can eventually be followed right until it's purchased.

Within this labyrinth, Roberto Cavalli is as much at home as a fish in the sea – with good reason, for this is his natural habitat. Indeed, it's hard to picture him anywhere else. Roberto Cavalli is certainly nowhere near retiring. His enthusiasm, his curiosity, even his anxiety and anguish keep pushing him further. According to Oscar Wilde, *"those whom the gods love grow young"*. The gods obviously adore Roberto Cavalli.

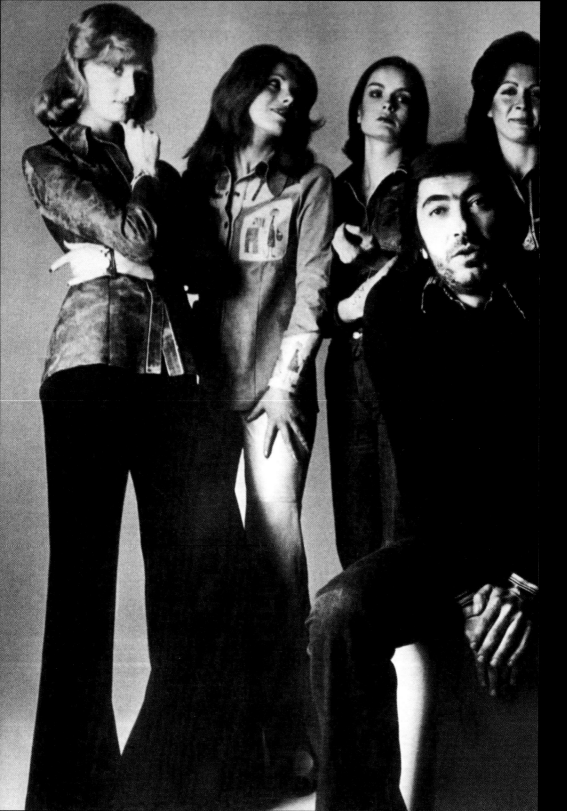

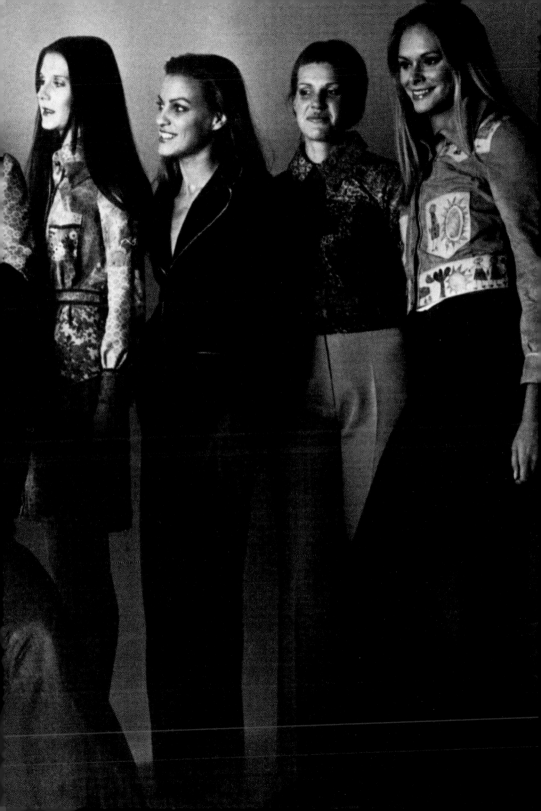

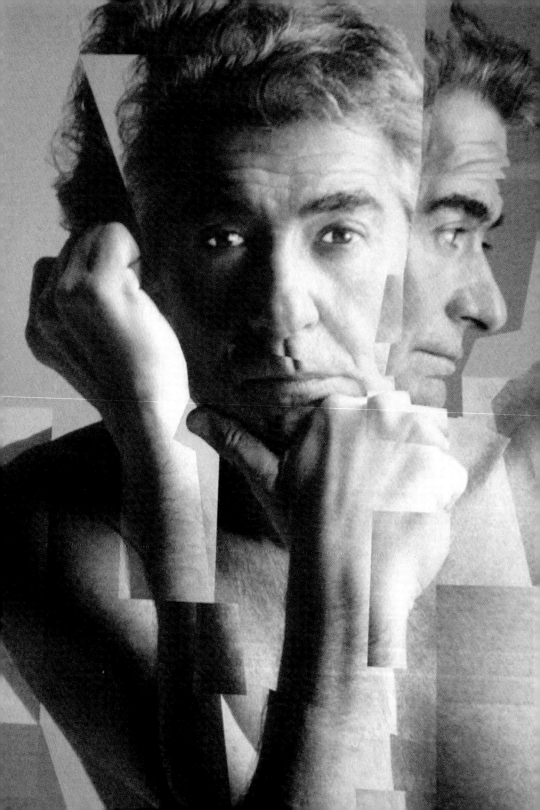

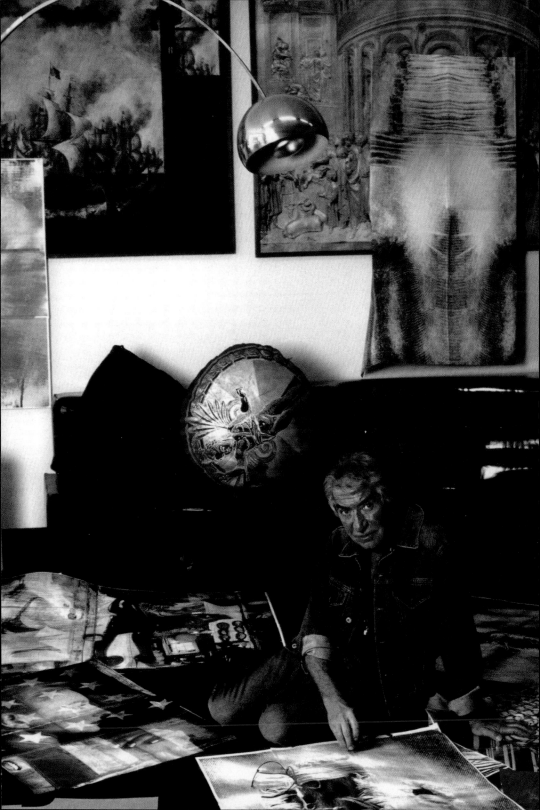

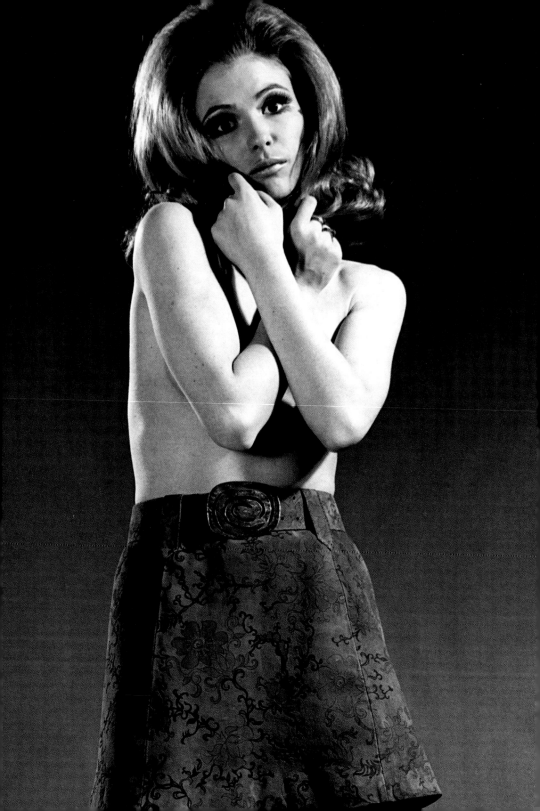

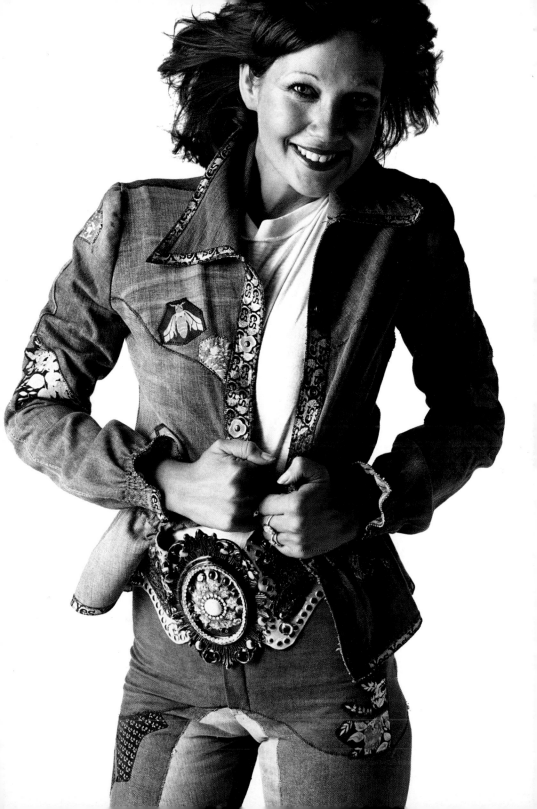

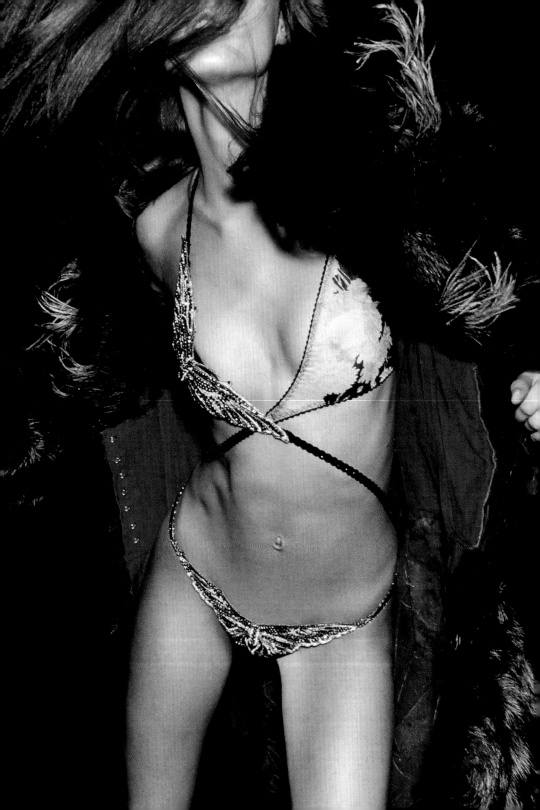

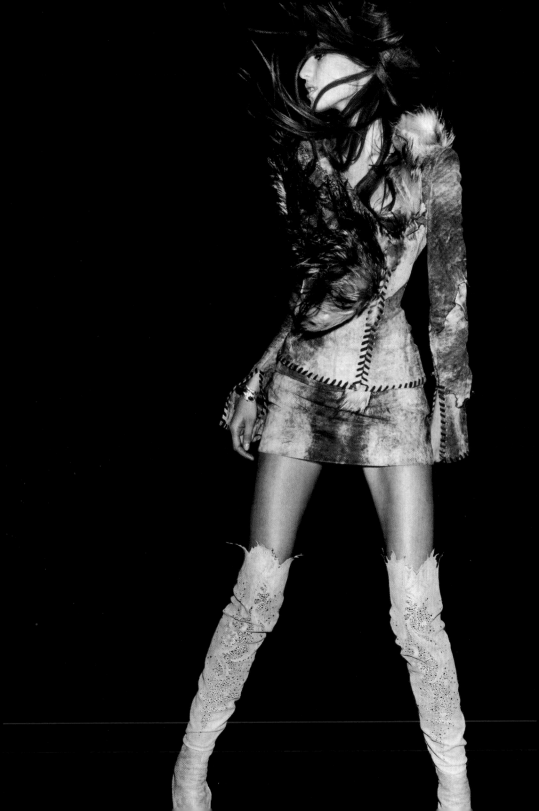

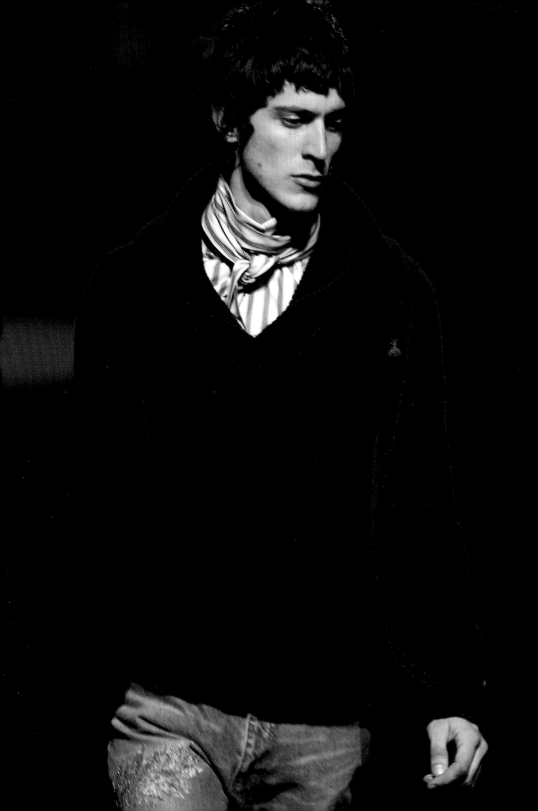

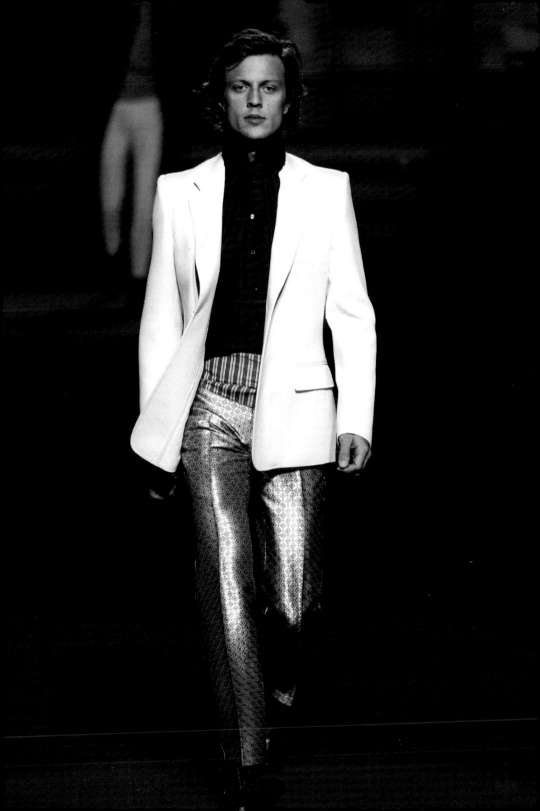

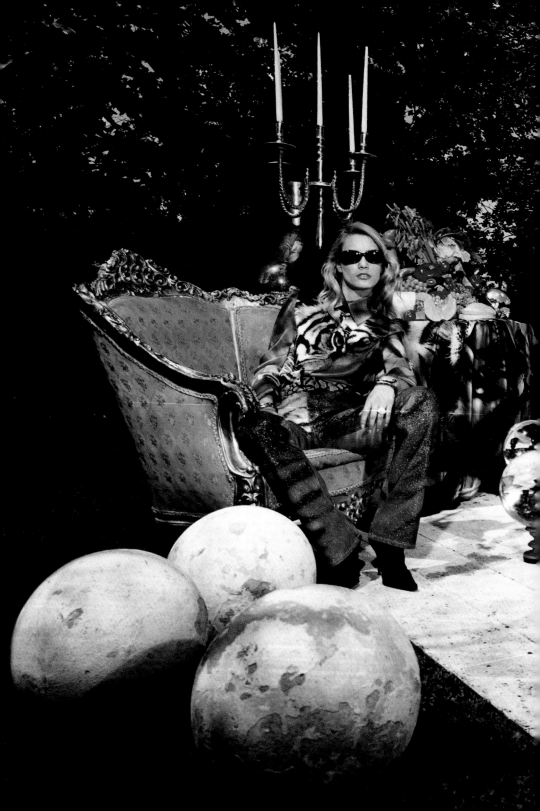

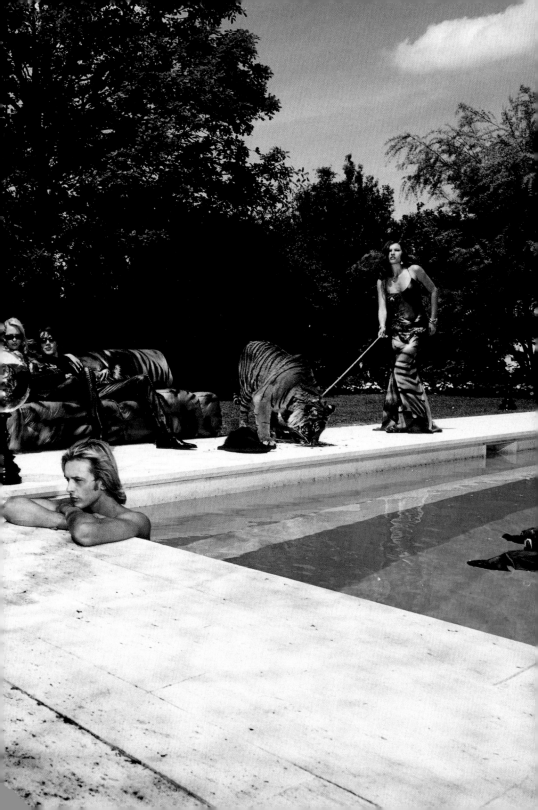

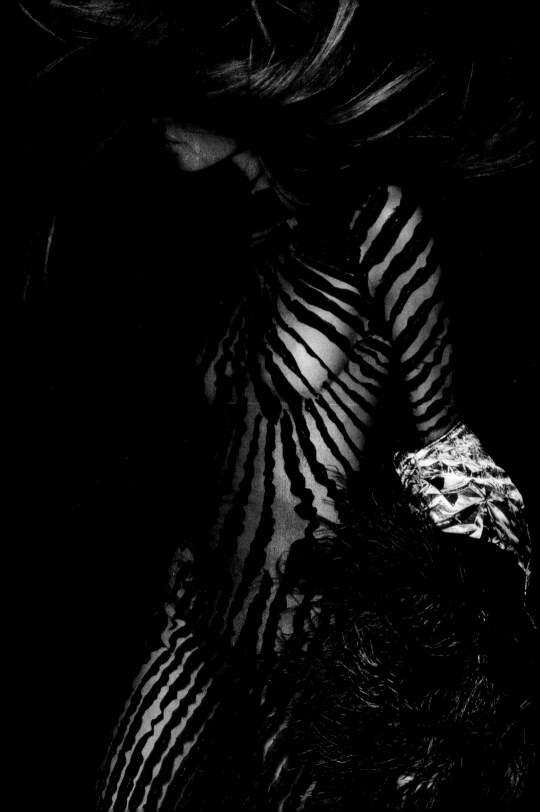

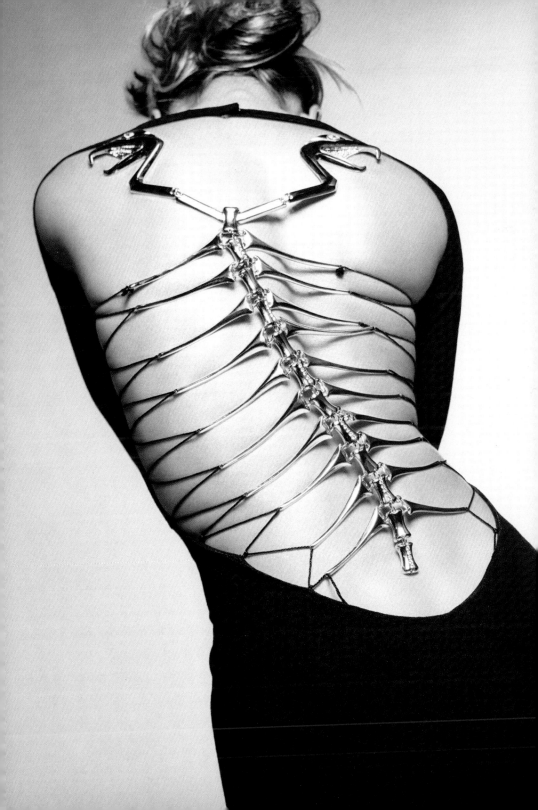

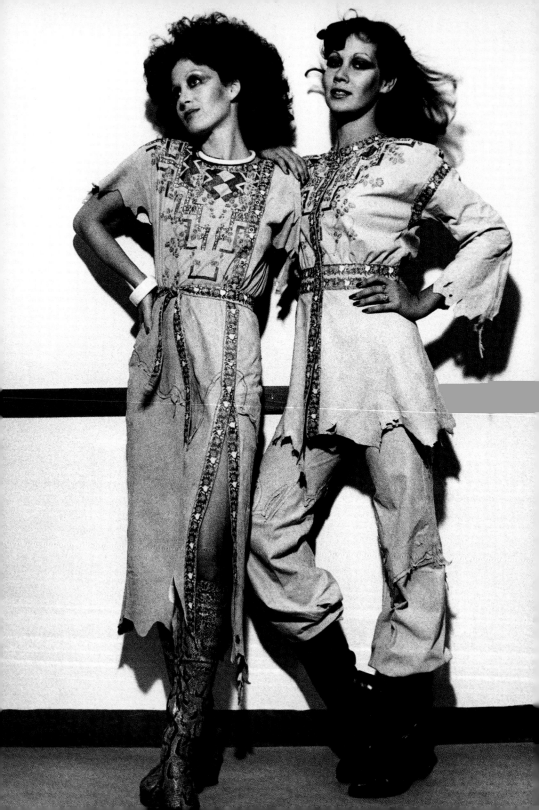

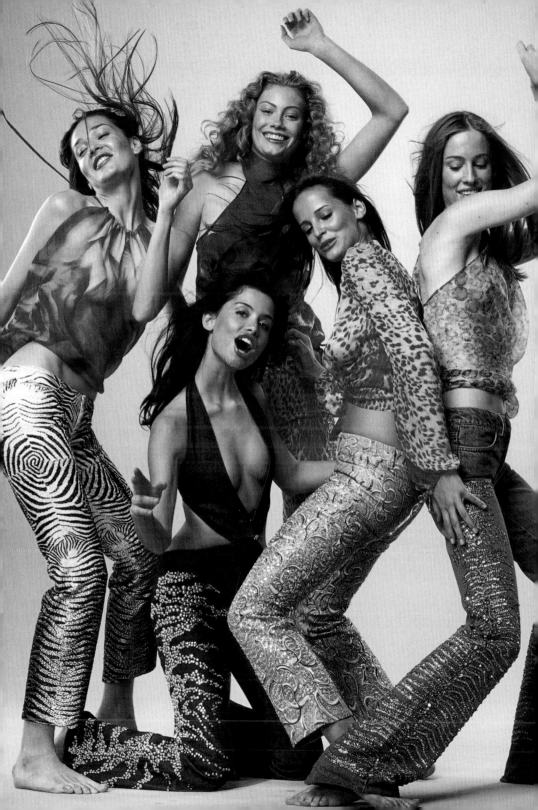

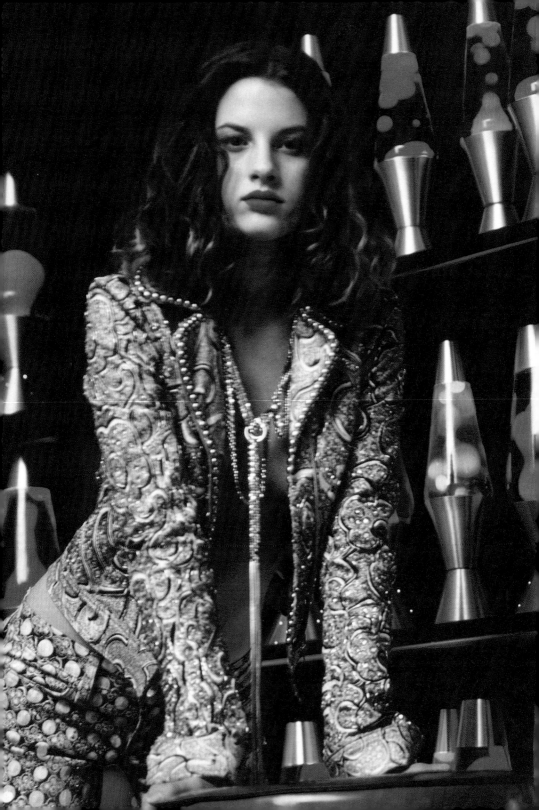

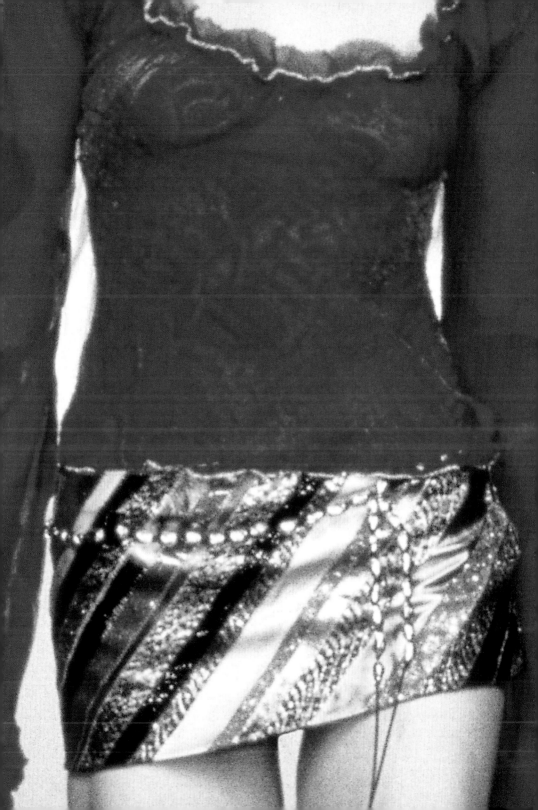

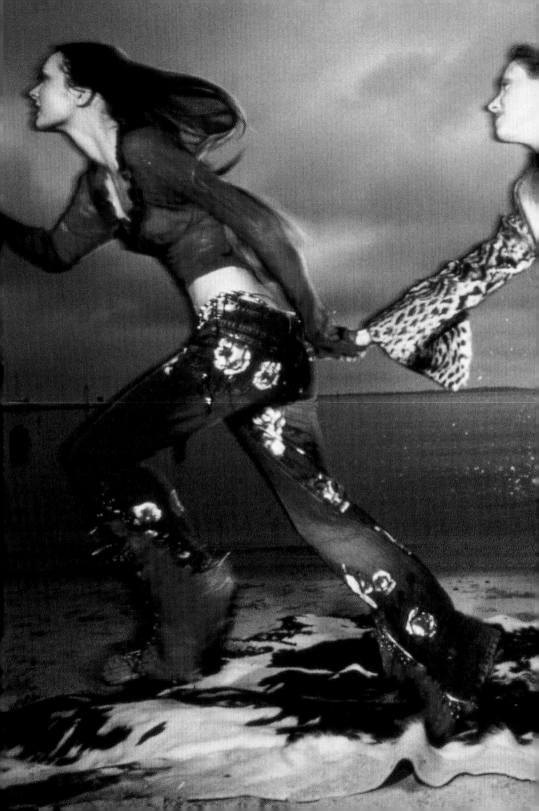

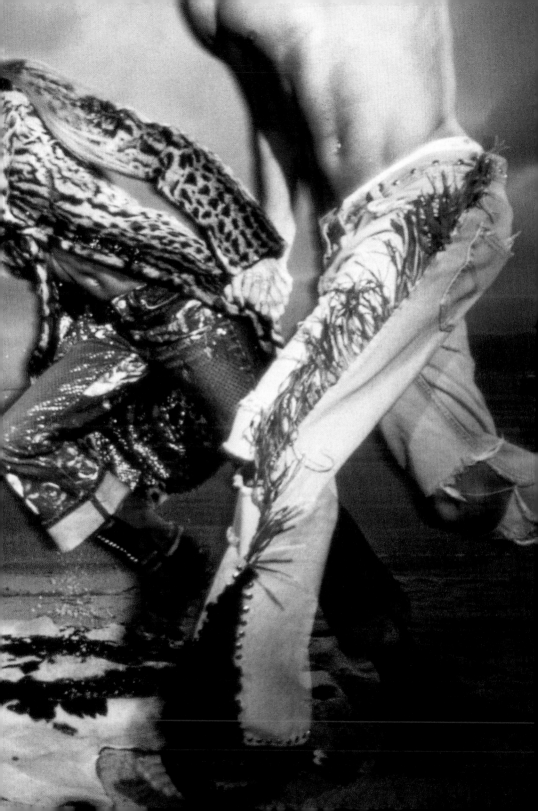

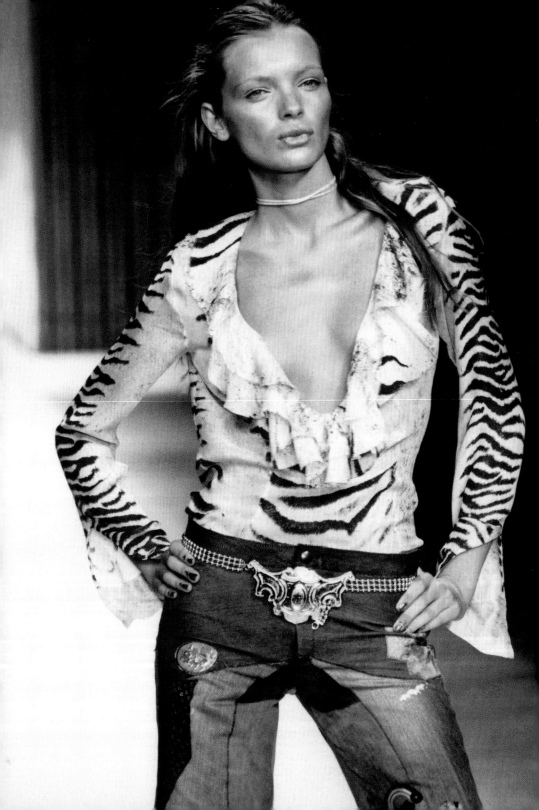

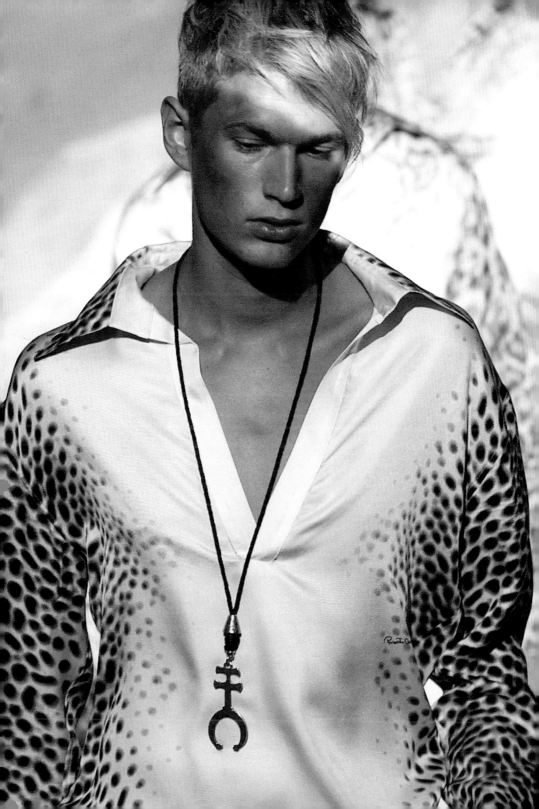

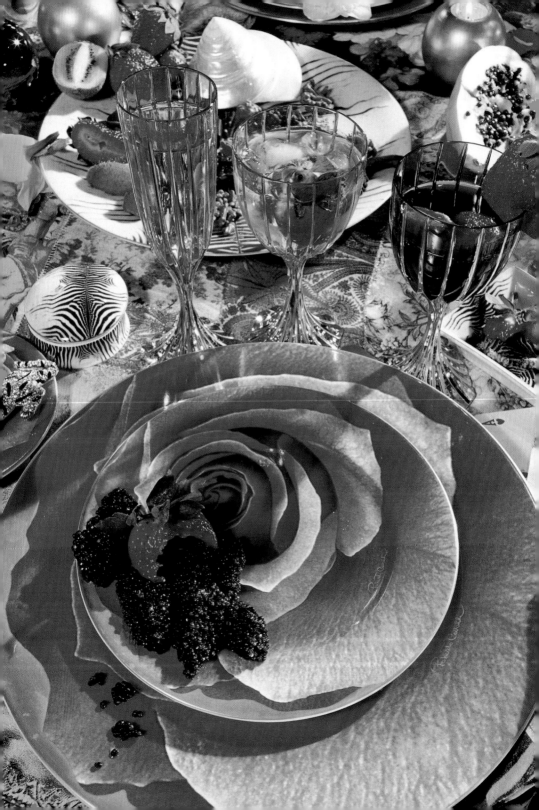

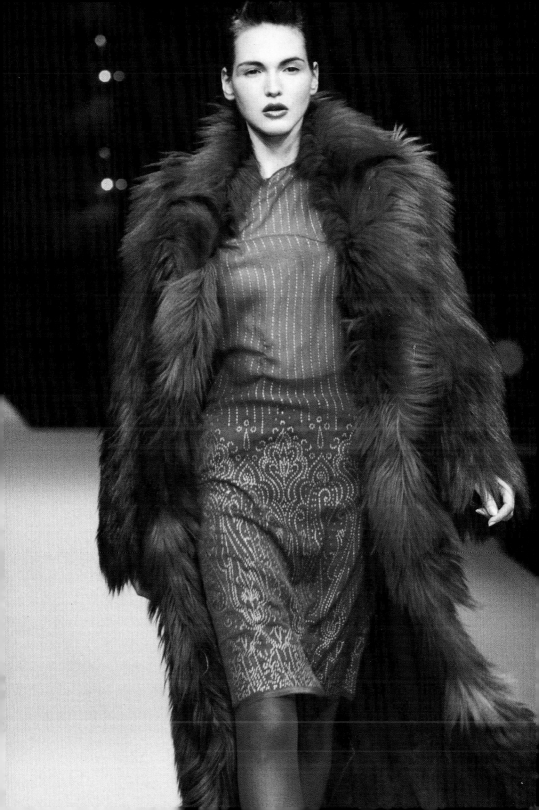

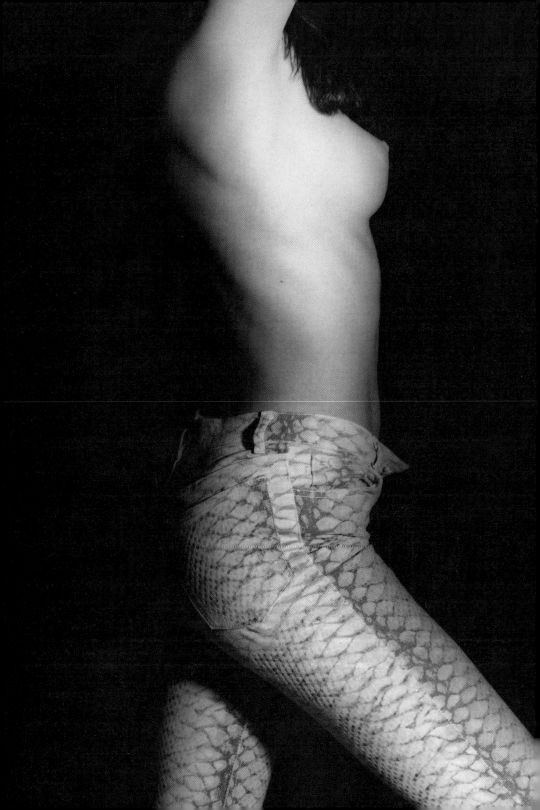

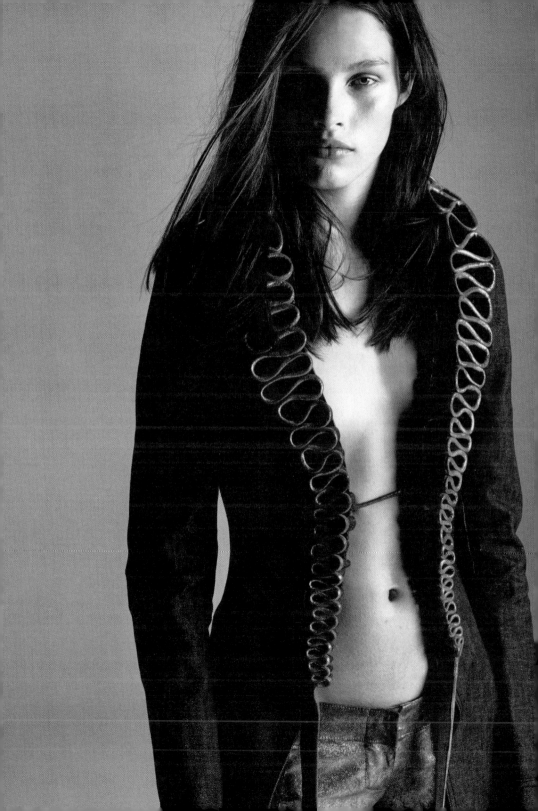

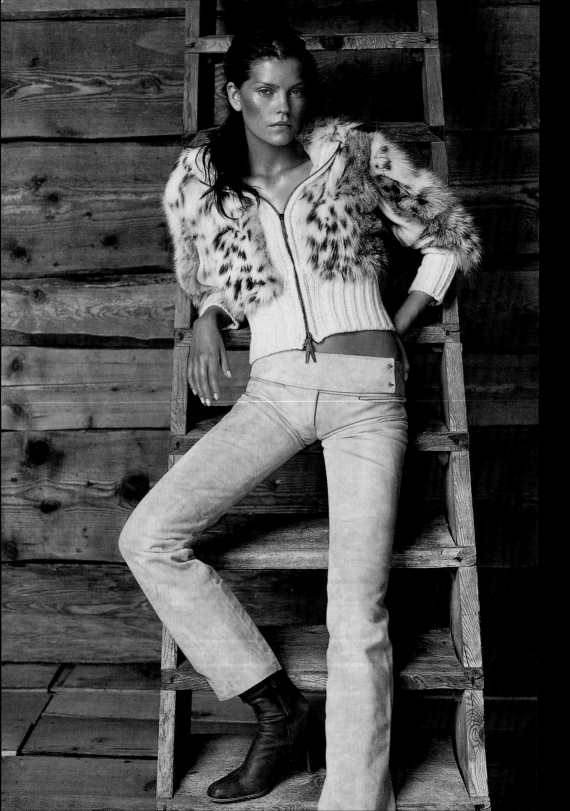

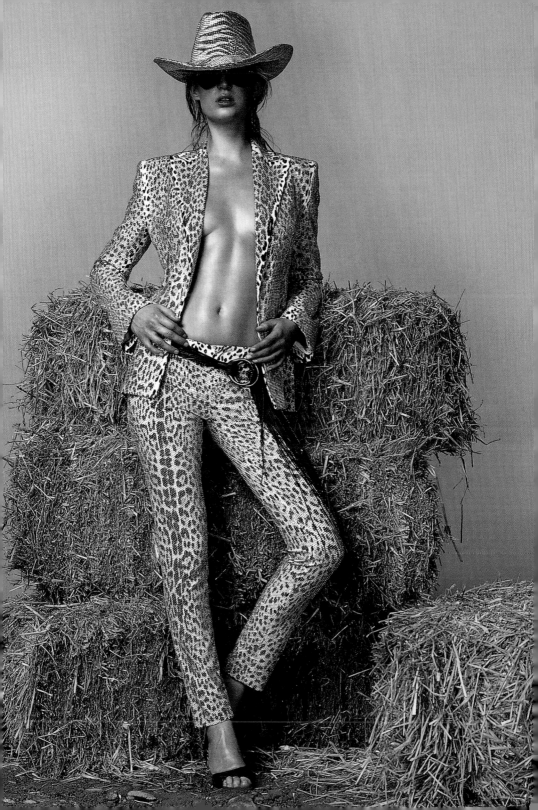

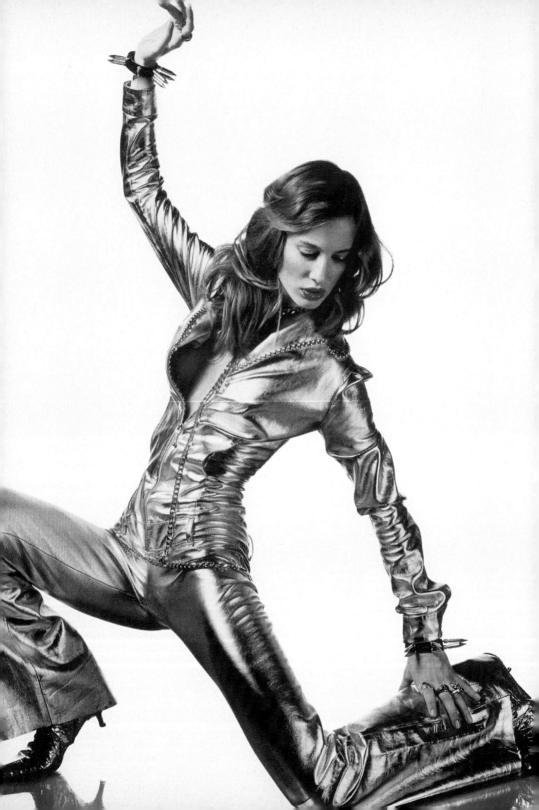

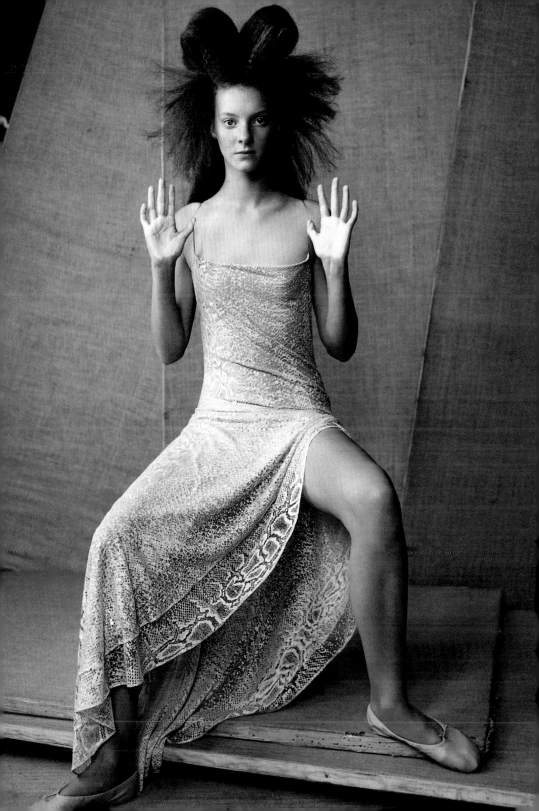

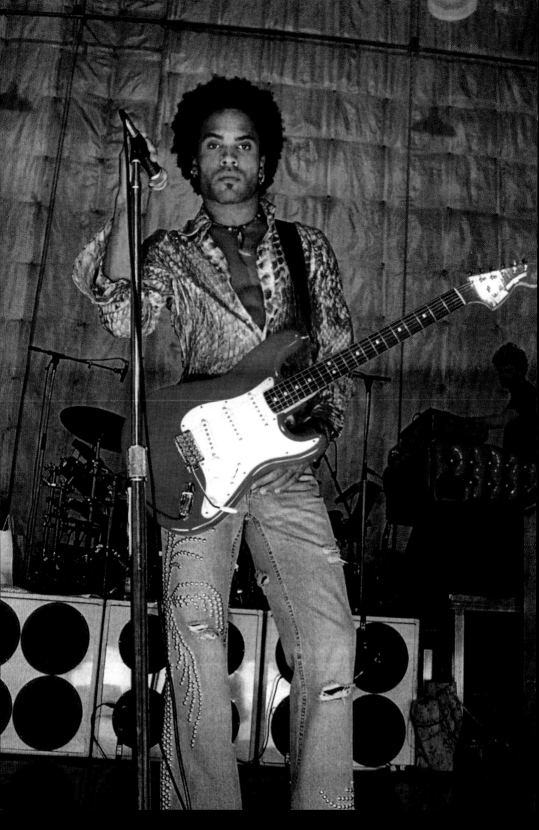

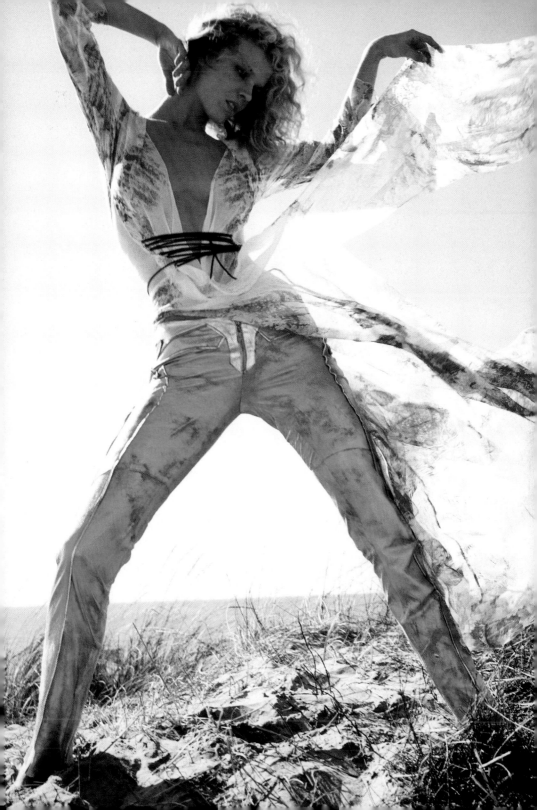

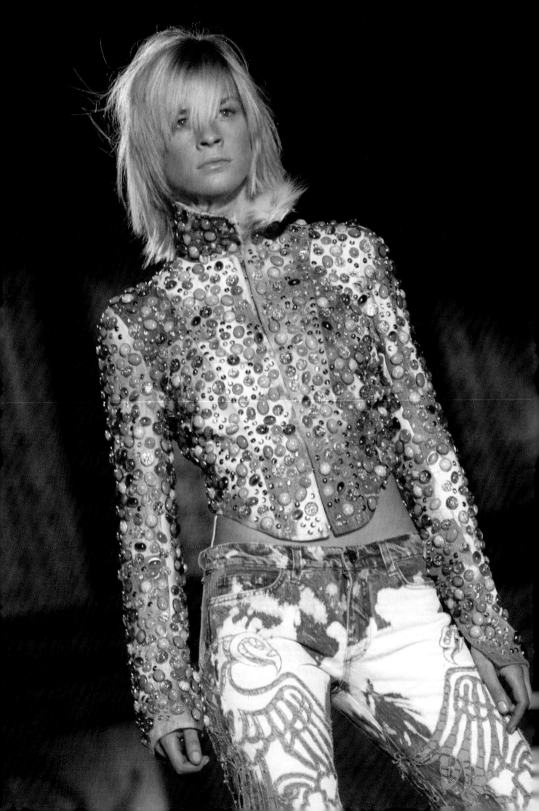

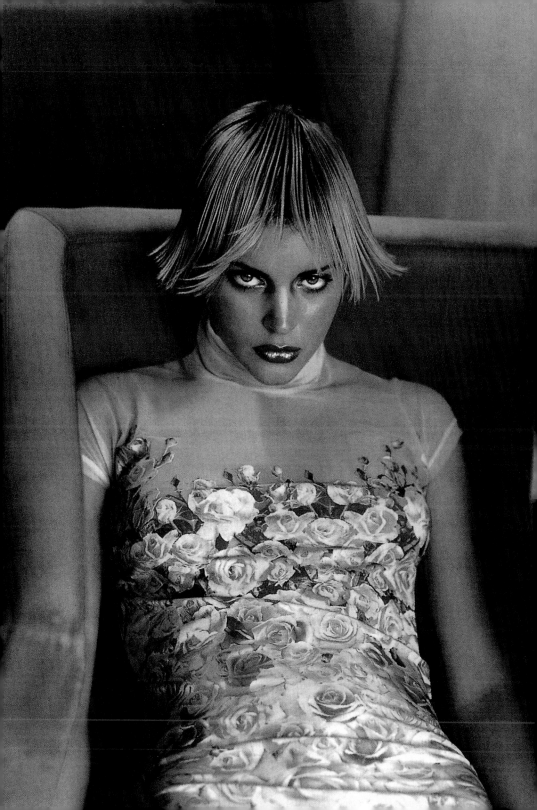

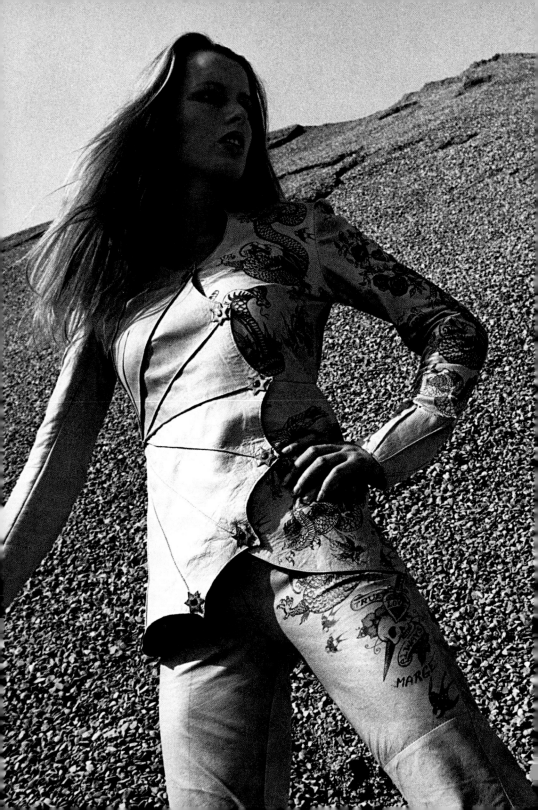

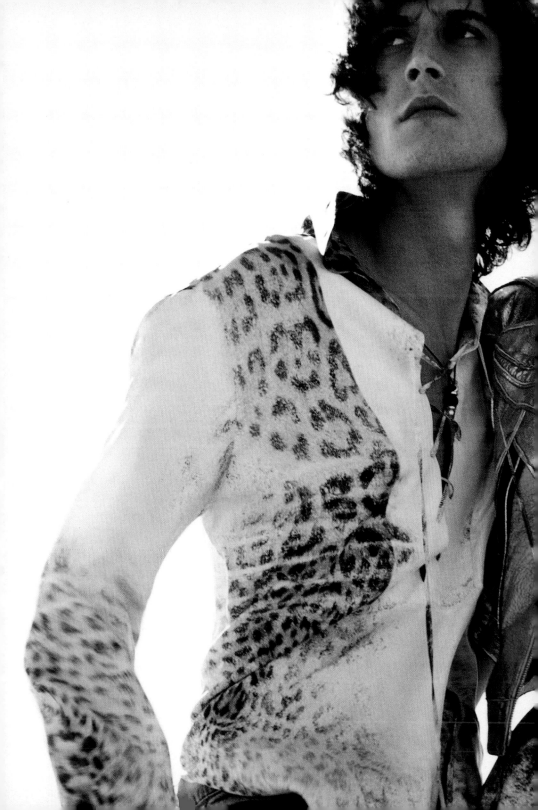

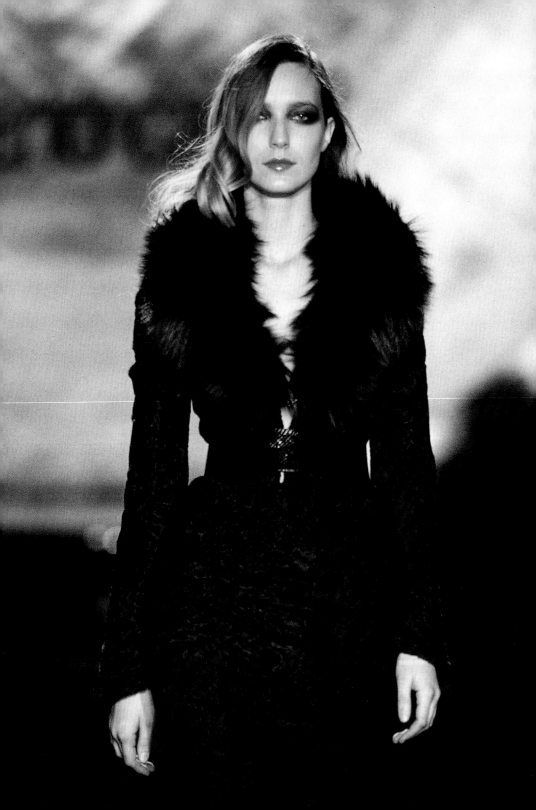

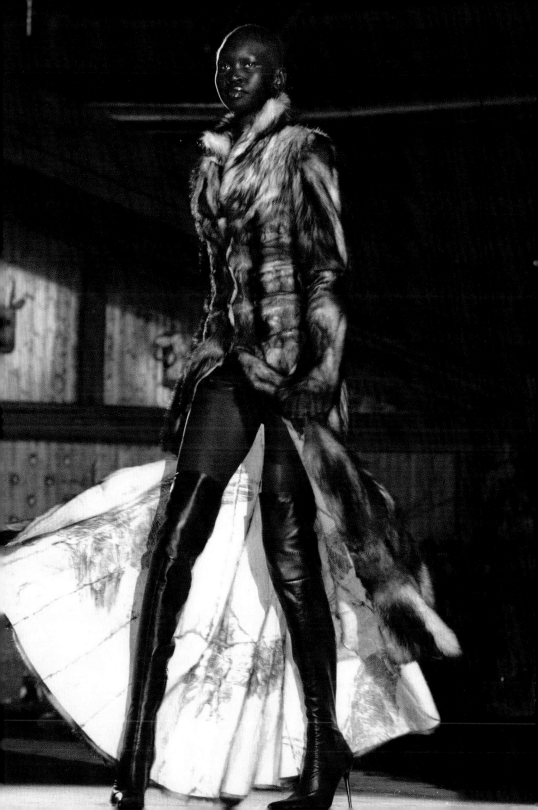

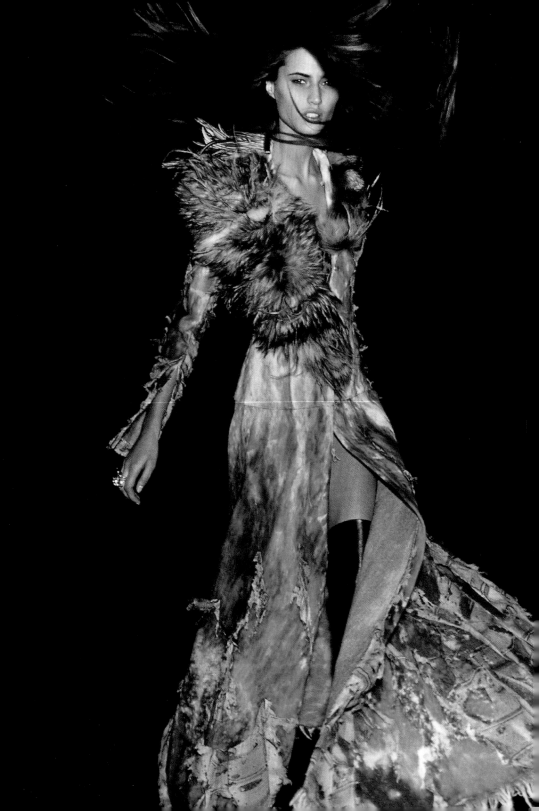

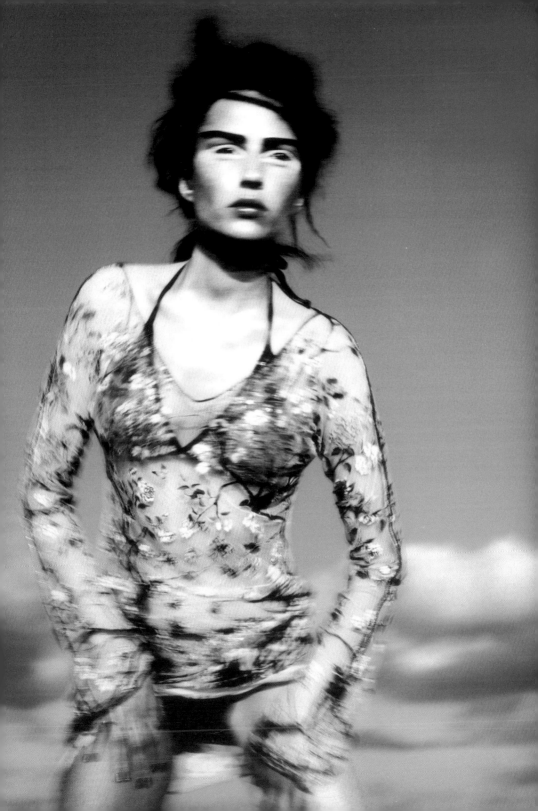

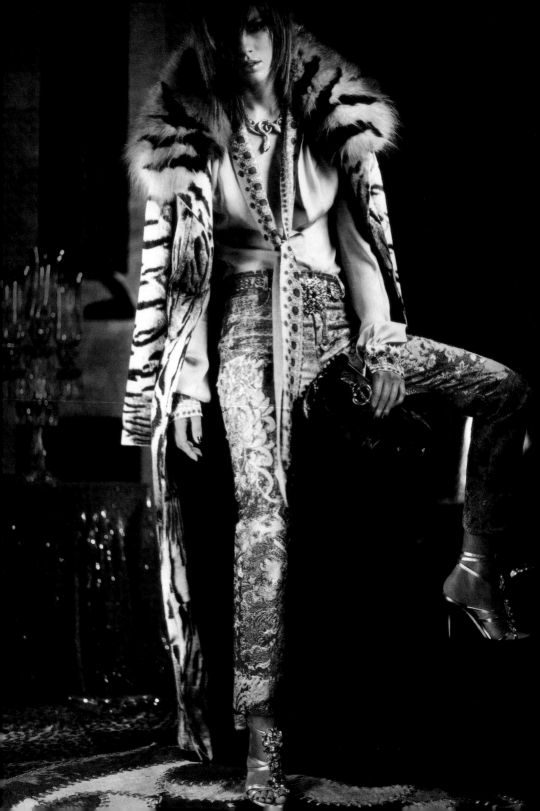

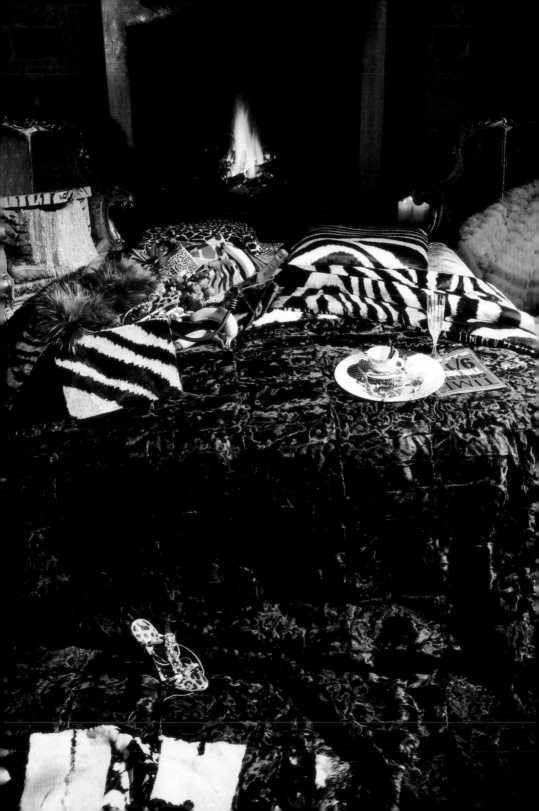

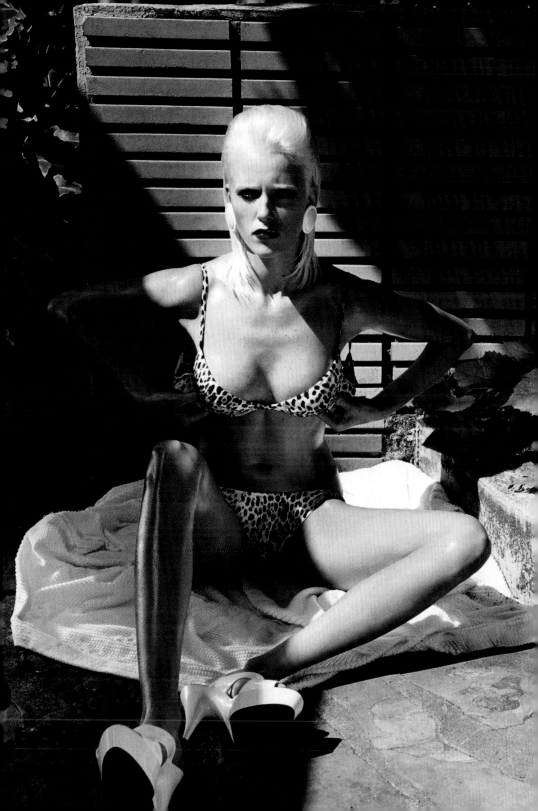

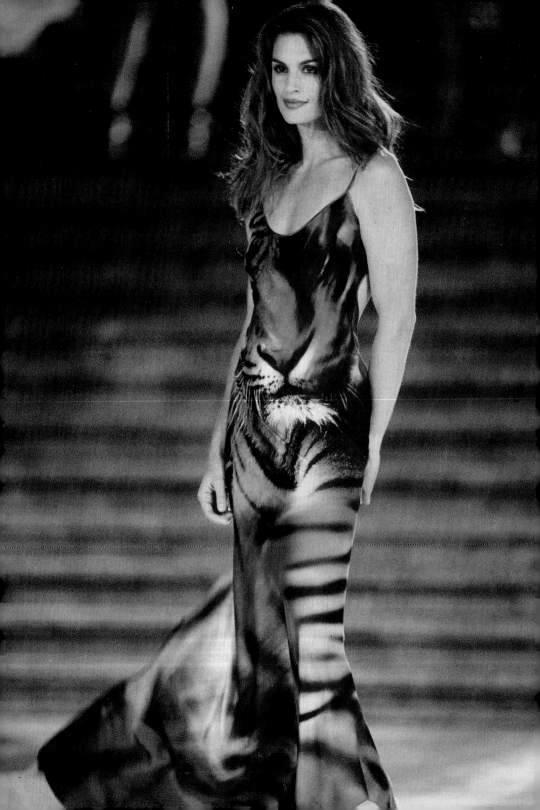

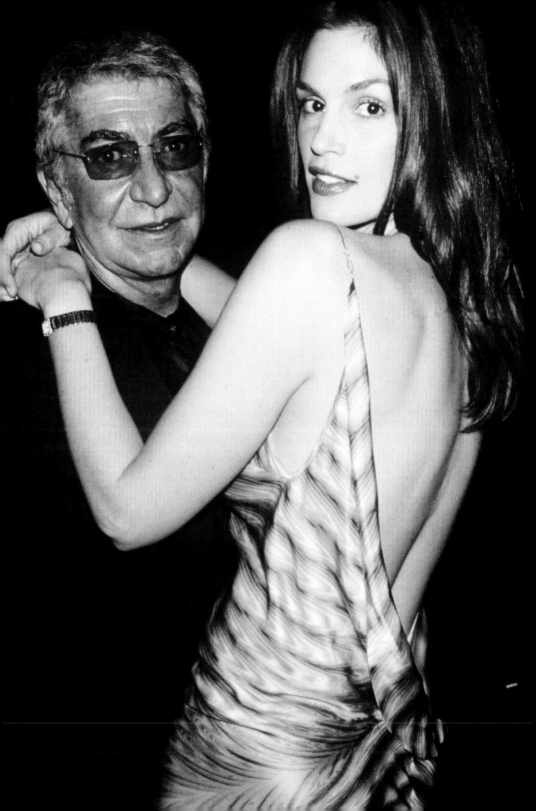

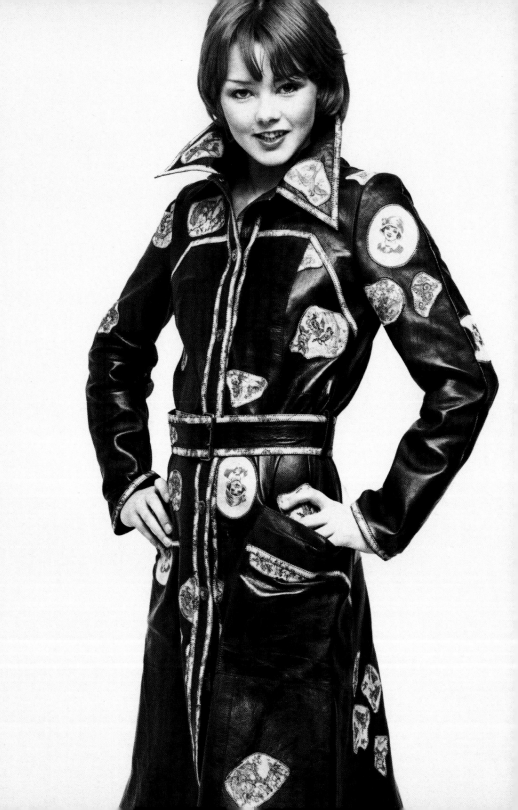

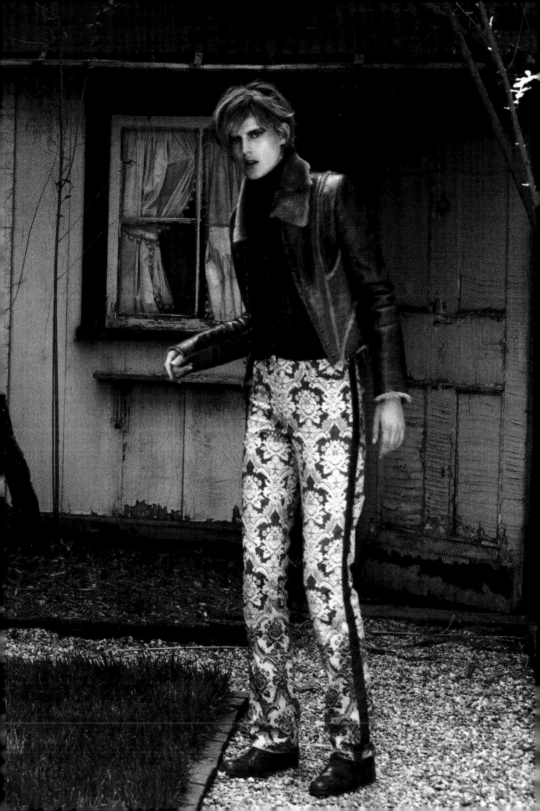

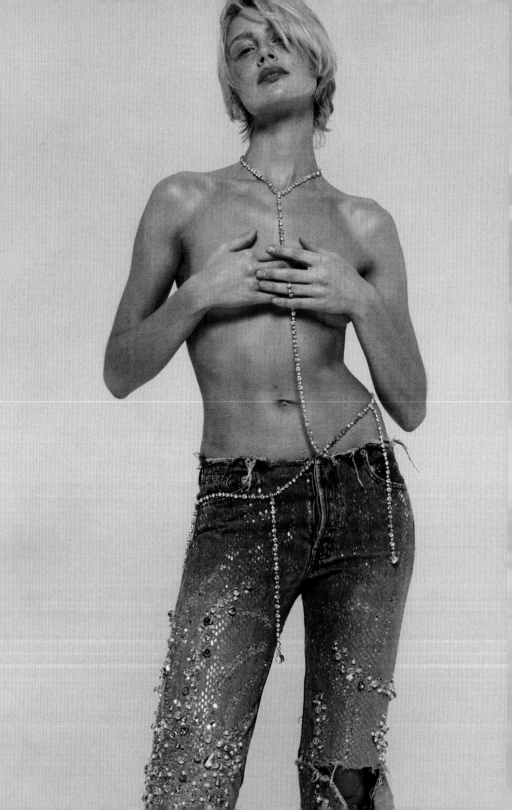

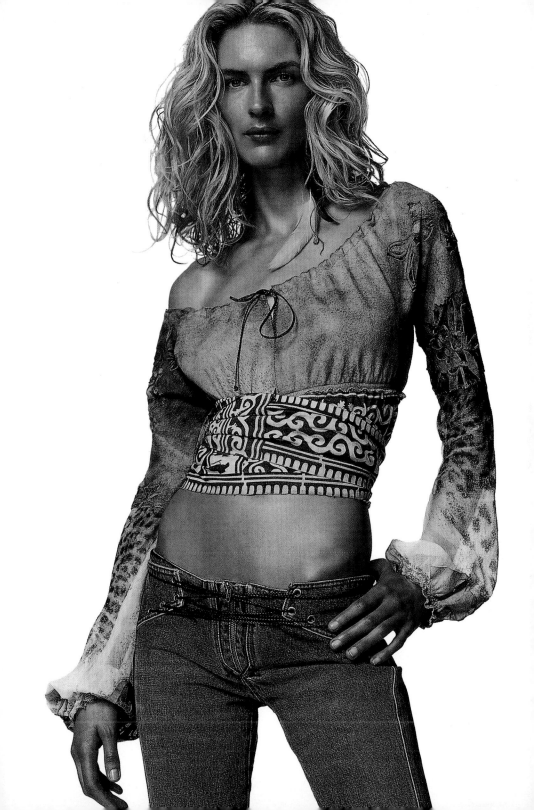

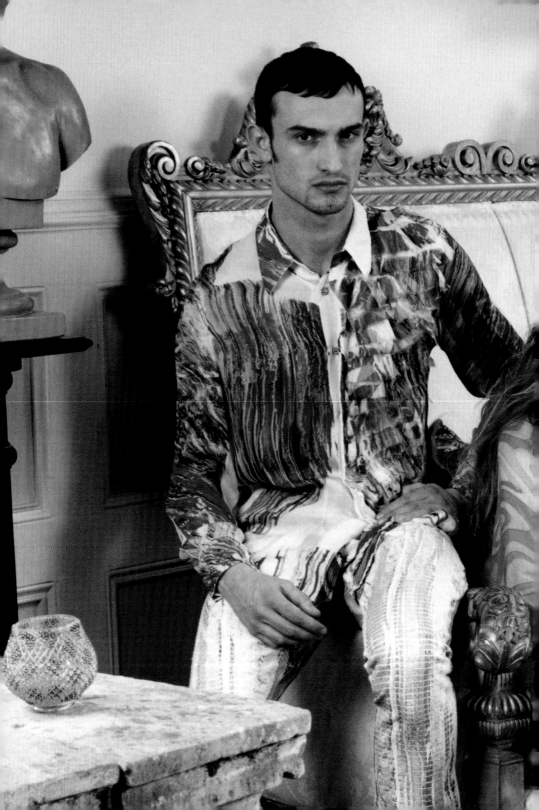

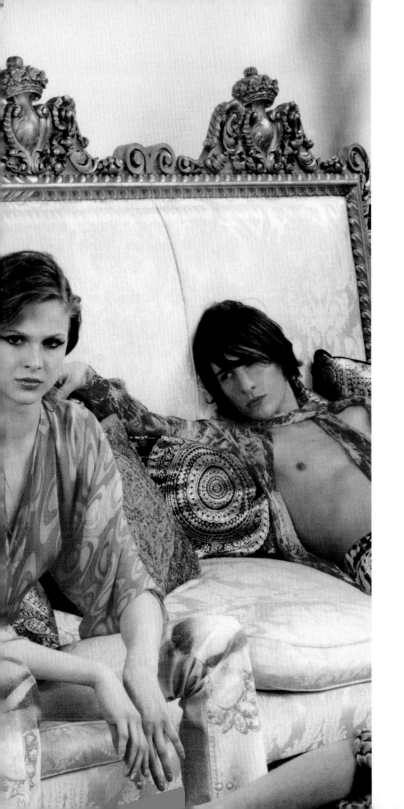

COSMOPOLITAN

MENSILE FEMMINILE PIÙ LETTO IN EUROPA

GIUGNO 2002 N.6
Euro 2,50 (IVA)

COGLI L'ATTIMO

Fee *sprint* per fare
sesso quando il tempo
stringe. (Breve sì, ma
moolto intenso!)

Alta fedeltà

scopri subito
e stai con
un farfallone

MODA

Passione latina

Con lo stile più **hot**
farai strage di cuori

8 "POSTI" AL SOLE

lavori estivi
che stavi
spettando

Jennifer Lopez

Voi chiedete,
la superchica
risponde

DIETA-TREND

Copia le star:
specchiati e leggi
sul tuo viso cosa
mettere nel piatto

Stasera mi butto!

Superguida
per single
alla riscossa

CELLULITE, ADIOS

con le creme
più efficaci

VOGUE ITALIA

GIU. 1999
N.586
L.8.500

jeans, sun and summer

ROBERTO CAVALLI

Canada's fashion magazine

FLARE

YOUR SEXIEST HAIR YET!

2 NEW PRO TRICKS

SPECIAL!
GYNO GUIDE
NEWS YOU CAN
USE FROM A–Z

105 BRIGHT FASHION IDEAS

KICK BUTT
FITNESS TIPS
WWF STYLE

KIM CATTRALL
HER BETTER
IN BED TIPS

$3.50
05
May 2002
www.flare.com

over $600—
& more

ELLE

oroscopo
un'estate
da scoprire

GIU

LIFESTYLE
PROFONDO BLU

nuova femminilità
qualcosa di lui

MODA
NERO SENTIMENTALE, MIX ETNICI
COSTUMI FANTASIA, STILE BALLERINA

HOLLYWOOD
COLLEZIONISMO
DA STAR

voglia
di maternità
40 idee
fertili

N. 6 - SPED. IN A.P. - 45% - ART. 2 COMMA 20/B HEGF 662/96 - FILIALE DI MILANO

Chronology

1940: Born in Florence on 15th November.

1944: Father shot by German Army in reprisal for Italian resistance activities. Spends childhood with mother and sister in the home of his maternal grandfather, the painter Giuseppe Rossi.

1957: Enrols for painting course at the Florence Arts Institute. Takes special interest in textile application.

1960: Starts printing on knitwear – products soon in great demand from the Italian knitwear sector.

1964: Marries Silvanella Giagnoni. Daughter Cristiana born in 1965.

1966: Opens factory and workshops at Osmannoro to the north of Florence, later to become a major industrial area.

1968: Creates leather printing technique. First Paris collection, shown at the Porte de Versailles Salon. Birth of son Tommaso.

1971: Fashion show at the Pitti Palace in Florence, as part of the official Italian designer collection.

1972: Jeans recycled into patchwork. Metallized leather. Huge success. Opens boutique in Saint Tropez, for affluent clientele seeking de luxe versions of up-to-the-minute non-conformist look.

1978: Meets Eva Duringer in Santo Domingo, where she wins the Miss Universe title. They marry in 1980.

1982: Birth of their daughter Rachele. Retires from Italian fashion scene but continues to show collections in Düsseldorf and New York, while designing and creating prints for other brand names.

1986: Birth of son Daniele.

1990: Eva joins the Cavalli firm as Roberto's assistant.

1993: Presents Cavalli stretch jeans, sandblasted to achieve aged look, at the Modit Salon in Milan. An instant hit that relaunches his career. Birth of Robin, Eva and Roberto's third child.

1994: First Milan show for Cavalli's return. Opens a boutique in Gustavia, Saint Barth, in December.

1995: Opens boutique in Saint Tropez, on Place de la Garonne.

1997: Opens first Italian boutique, in Venice.

1998: Launches the Just Cavalli range for young people.
Opens Paris boutique.

1999: Opens New York boutique.

2000: New lines created to complement and enrich the Cavalli fashion world: lingerie, interior decorating, sunglasses, watches, children's clothes, ties, scarves and accessories.
New boutique opens in Milan.

2001: New boutiques in Rome, Marbella and Capri.

2002: Florence pronounces the11th January as Roberto Cavalli Day during the Pitti Uomo men's fashion salon, as a tribute to the international stature gained by one of its citizens.
Inauguration of the boutique on Via Tornabuoni.
Show for the men's 2002-2003 Autumn-Winter collection, in the truly magnificent setting of the Cinquecento Salon in the Palazzo Vecchio, and the official opening of an exhibition entitled *More More More*, spanning the entire baroque world of Roberto Cavalli, in the Pitti Palace's Galleria degli Argenti.
Launch of Cavalli's first perfume for women.
Cavalli boutiques open in Miami and Mexico, then – in September and October – in Taipei and Las Vegas.

2003: New Cavalli boutiques: in Dubaï and Koweït City in January, then in London and Los Angeles.

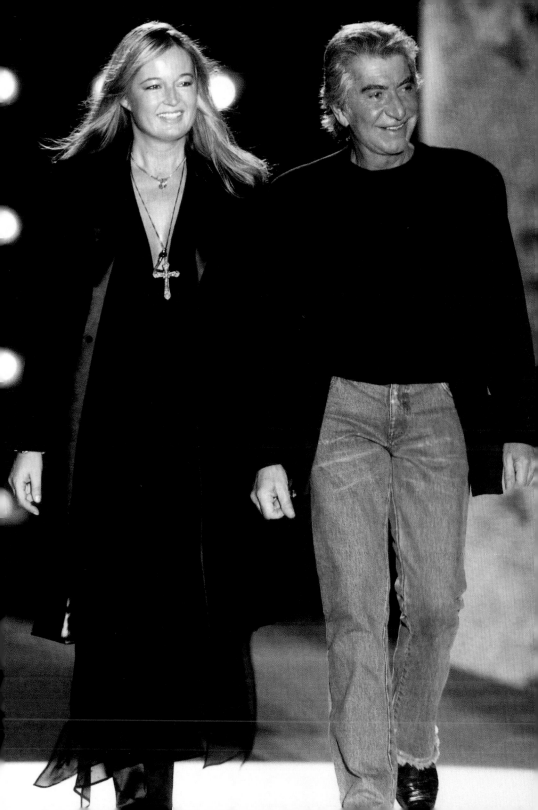

Roberto Cavalli

The Seventies according to Cavalli. The designer and his clothes—jeans, shirts, dresses—in the early years of the decade. © Roberto Cavalli Archives.

Portrait of Roberto Cavalli. © Photo Marco Glaviano.
Roberto Cavalli's office-cum-studio at his Osmannoro headquarters. © Photo Roberto Grazioli/Grazia Neri.

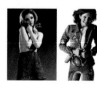

The invention of printed leather. Miniskirt. Late Sixties. © Roberto Cavalli Archives.
Printed suede patchworked shirt and trousers. © Roberto Cavalli Archives.

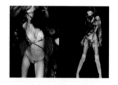

Mesh bikini, *Butterfly* print. Coat in a patchwork of fox with ostrich feathers. © Photo Mario Testino.
A unique style, instantly recognizable. Suede jacket and miniskirt inlaid with nappa leather. Red fox collar inlaid with silver fox and ostrich and pochard feathers. Lace-like suede boots with topaz strass. © Photo Mario Testino.

A new, vivacious approach to luxury. Striped cotton shirt. Cashmere sweater and cardigan. Denim jeans embroidered with oxidized metal. © Photo Ugo Camera.
Black silk twill shirt. Double silk-wool jacket. Striped cotton sash. Silk jacquard trousers. © Photo Ugo Camera.

The comic-strip baroque inventory of an intensely Italian creator. Advertising campaign AI 00/01 Tigre Point, shot at the Cavallis'villa, near Florence. © Photo Steve Hiett.

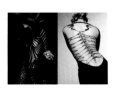

The skill of an expert craftsman and the uninhibited imagination of an artist: Laser-slashed, embroidered evening gown. Silk chiffon on silk tulle. Wet-like ostrich feathers coat lined in silk satin, with a *Cristal de Bohème* print. © Photo Mario Testino.

Wool crêpe evening gown, its plunging back ornated with a golden metal piece of jewelry. © Photo Sabine Liewald.

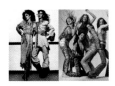

Flower Superpower. Navajo-inspired embroideries, fringes and ribbons on a suede dress and a suede ensemble. 1970's. © Roberto Cavalli Archives.

Contrasts and vibrations. Stretch denim jeans with jet, canottiglie and strass zebra embroideries. Flower printed chiffon tops and blouses. © Photo Tom van Heel/NEL.

Sparkling and lavish, sharp and rakish. Embroidered *Jewel* print stretch cotton drill jacket and jeans. © Photo Maria Vittoria Backhaus/MaxPPP-Iodonna.

Top made of a dyed patchwork of dévoré velvet. Miniskirt of a leather patchwork with a *Glitter* print. © Photo Ugo Camera.

The body is taken care of, flattered or even corrected, if necessary. Hand-painted denim jeans with Mongolian fur inserts and fringes of small corals. Silk crêpe top with a *Poppy* print. XVIIIth C.-style tailcoat in Lippis fur. Hand-painted denim jeans. In the foreground, vintage Cavalli blue jeans with suede fringes and leather inserts. © Photo Steve Hiett.

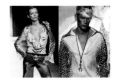

Now and always, cheerful, bold, uncommon jigsaws and collages. Flounced blouse in zebra silk satin chiffon. Vintage Cavalli jeans in a patchwork of denim and printed leather. © Photo Piero Biasion.

Decidedly flamboyant. Silk twill shirt, *Paradise Fish* print. Hammered brass accessory. © Photo Ugo Camera.

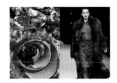

The doctrine of glamour. China plates with hand-applied gold pattern on red *Dark Lady* print. © Photo Michael Baumgarten.

Fuchsia-dyed kiddassia coat. Dress in chiffon dévoré, *Glitter* print. © Photo Piero Biasion.

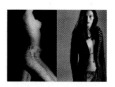

Captivated by textiles and materials like a painter by canvas. Cotton drill jeans, scales effect. © Roberto Cavalli.
18th Century-style tailcoat in unwashed denim with metallized leather pattern. © Photo Wayne Maser/A+C Anthology.

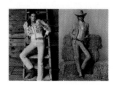

Bomberino jacket in hand-worked lynx and cashmere. Velvety leather trousers. © Photo Rennio Maifredi/Frame-Marie-Claire.
Leopard printed cotton tailleur, entirely micro-perforated. Printed satin cow-boy hat, entirely micro-perforated. © Photo Rennio Maifredi/Frame-Marie-Claire.

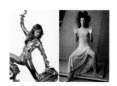

Playing with excess. Gold nappa pantsuit. © Photo Christophe Meimoon/Elle Scoop.
Updating the concept of gilded youth. Dévoré silk jersey evening gown, Python print. © Photo Ruben Afanador/Vogue Germania.

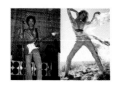

Fashion show. Lenny Kravitz in a crumpled silk twill shirt, *Macrosnake* print and perforated denim jeans. © HK Management Inc.
A theatrical twist. Caftan in printed crêpe chiffon on satin, metallized and aged suede trousers. © Photo Mario Testino.

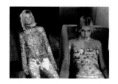

The sex factor. Small jacket in bleached denim encrusted with semi-precious stones, Murano glass and metal eyelets. Jeans in embroidered bleached denim. © Photo S. Cardinale/Corbis Sygma.
Dévoré stretch coton T-Shirt, *Rose bouquet* print. © Photo Blasius Erlinger/ Madame Figaro.

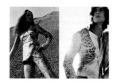

Beige jacket with a multicolor print and star-shaped snap buttons in enameled metal. 1970's. © Roberto Cavalli Archives.
Cavalli Archetype. Worn-like *Jaguar* silk satin shirt. © Photo Mario Testino.

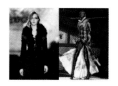

At odds with any kind of modesty. Tailleur in Breitschwanz with black fox collar and black python belt. © Photo Ugo Camera.
Redingote in unlined and hand-painted puzzola. © Corbis Sygma.

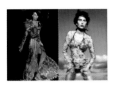

The very act of dressing becomes an event. Washed denim redingote lined with printed chiffon. Assymetrical collar in Murmasky fur with coyote fur inserts and emu feathers. © Photo Mario Testino.
The persistent colors of a high-tech rainbow. Dévoré viscose jersey minidress. Lycra bathing suit. © Michael Wooley/Elle Germany.

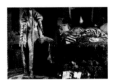

What good old fashion drama is all about. Striped leather coat adorned with a fox skin collar. Chiffon blouse. Stretch trousers with tweed pattern and patchwork appliqué. © Photo Mario Testino.
Black roebuck bedcover. Cushions in a zebra giant print. Zebra printed silk sheets. © Photo Michael Baumgarten.

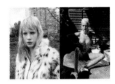

Fur jacket. Autumn-Winter 2000-2001 collection. © Photo Paulo Sutch.
Lycra bikini, animal print. © Photo Steven Meisel/Vogue Italy.

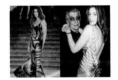

Rich and famous – and best friends. Cindy Crawford in a tiger print evening gown with a red fox tail. © Photo Maurizio D'Avanzo/pmf agency.
Cindy Crawford and Roberto Cavalli. Turquoise silk long dress, *Venice* print. © Photo Gregory Pace/Corbis Sygma.

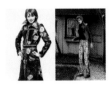

Striking visual power. Leather coat. 1970's. © Roberto Cavalli Archives.
Small jacket in shearling. Brocart printed jeans with a crumpled red velvet band. © Photo Kelly Klein.

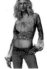

Blue jeans reinvented. Worn-like denim jeans inlaid with Swaroski pearls and crystals. Chains of strass. © Photo Roberto Orlandi/Grazia.
Printed silk chiffon and silk velvet-like suede blouse, laser-embroidered. Sash in cotton cloth from Indonesia. © Photo Rennio Maifredi/Frame-Marie-Claire.

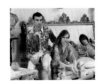

Under control profusion. Satin chiffon shirt. Cotton drill jeans, Murano Glass print. Satin chiffon caftan, Cocon print. *Jewel* print jeans. © Photo Jean-François Carly.

The author would like to thank Franca Sozzani and Grazia D'Annunzio.
The publisher would like to thank the company Roberto Cavalli, especially Eva
Cavalli, Cristiana Cavalli, Roberto Cavalli, Emanuela Barbieri and Marilù Benini.
He also wishes to thank A+C Anthology, Maria Vittoria Backhauss, Michael
Baumgarten, Piero Biasion, Ugo Camera, Ester Canadas, Jean-François Carly,
Condé Nast Italy, Corbis Sygma, Cindy Crawford, Elle/Scoop, Blassius Erlinger,
Marco Glaviano, Grazia, Roberto Grazioli, Maurizio D'Avanzo, Tom van Heel, Eva
Herzigova, Steve Hiett, Kelly Klein, Lenny Kravitz, Sabine Liewald, Madame
Figaro, Rennio Maifredi, Marie-Claire, Wayne Maser, Christophe Meimoon,
Roberto Orlandi, Stella Tennant and Mario Testino.